The Labyrinth

ILLUSTRATED BY RICHARD MERRITT AND SABINE REINHART

• EDITED BY HANNAH DAFFERN AND LAUREN FARNSWORTH • DESIGNED BY JACK CLUCAS • COVER DESIGN BY JOHN BIGWOOD •

The beasts in this book appear in the following order:

Minotaur • European Dragon • Jackalope • Basilisk • Gorgon • Cockatrice • Yeti
Pegasus • Ogre • Kraken • Gnome • Hydra • Harpy • Qilin • Kitsune • Unicorn
White Stag • Sphinx • Goblin • Gryphon • Faun • Phoenix • Chinese Dragon
Mermaid • Troll • Werewolf • Fairy • Manticore • Centaur • Sea Serpent • Cerberus

First published in Great Britain in 2017 by LOM ART, an imprint of
Michael O'Mara Books Limited, 9 Lion Yard, Tremadoc Road, London SW4 7NQ

 www.mombooks.com/lom Michael O'Mara Books @OMaraBooks @lomartbooks

A CIP catalogue record for this book is available from the British Library.

ISBN: 978-1-910552-61-2

3 5 7 9 10 8 6 4 2

This book was printed in China.

LOM ART

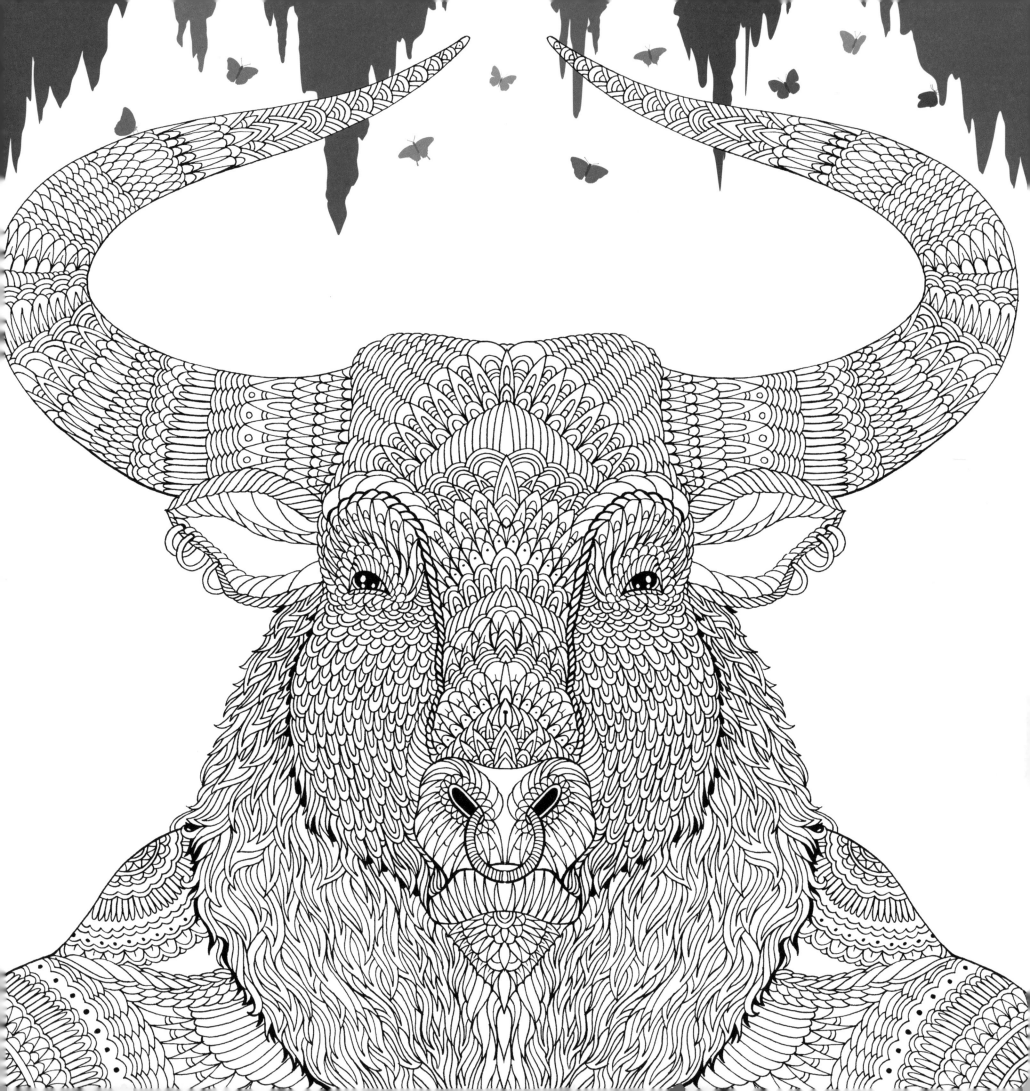

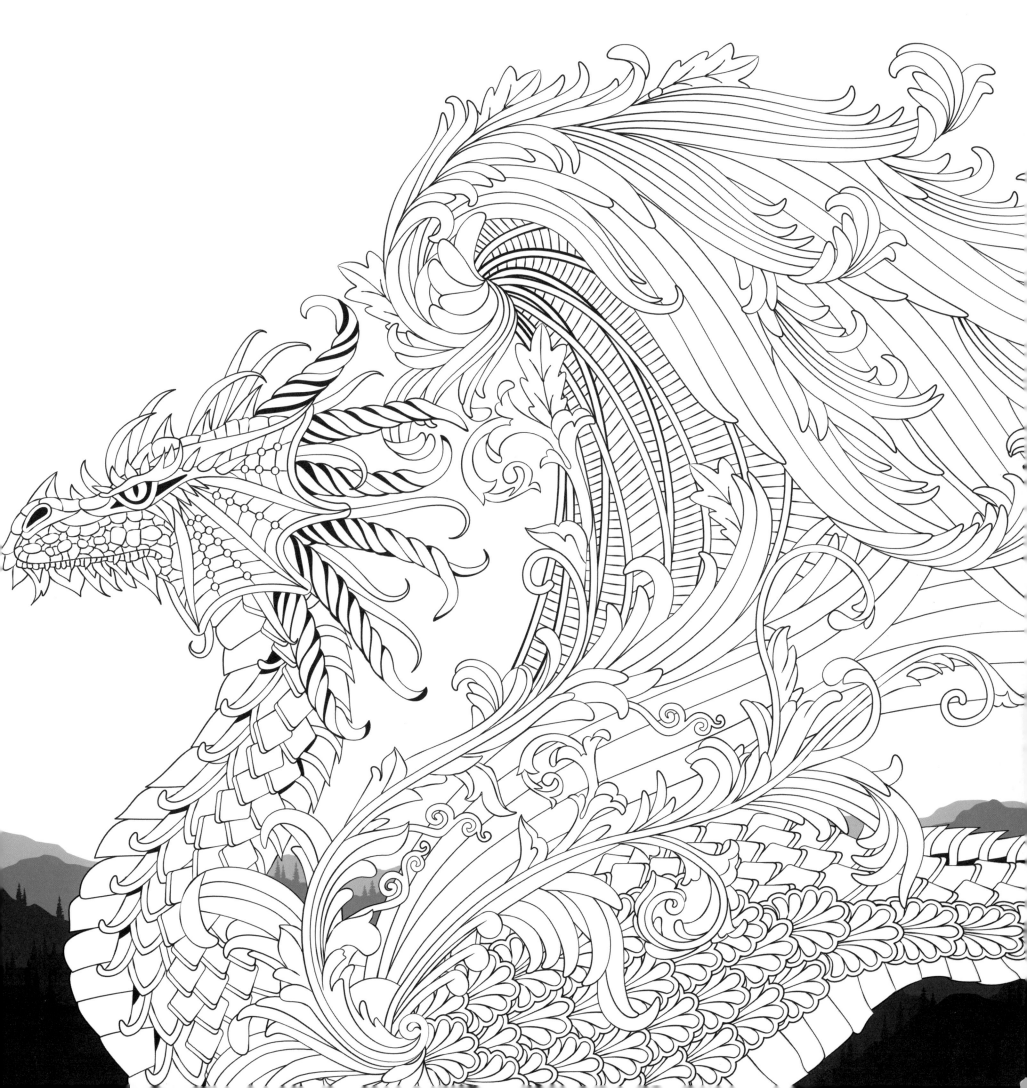

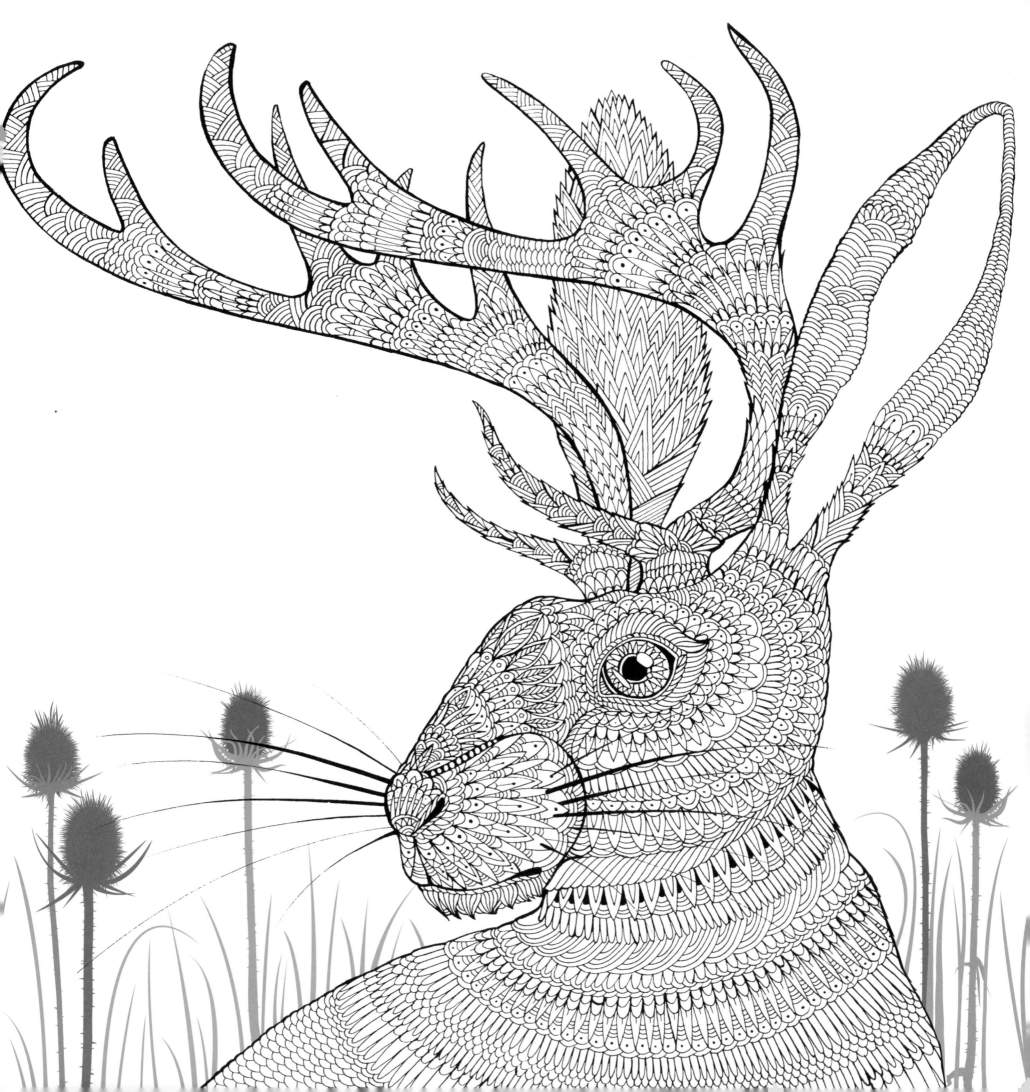

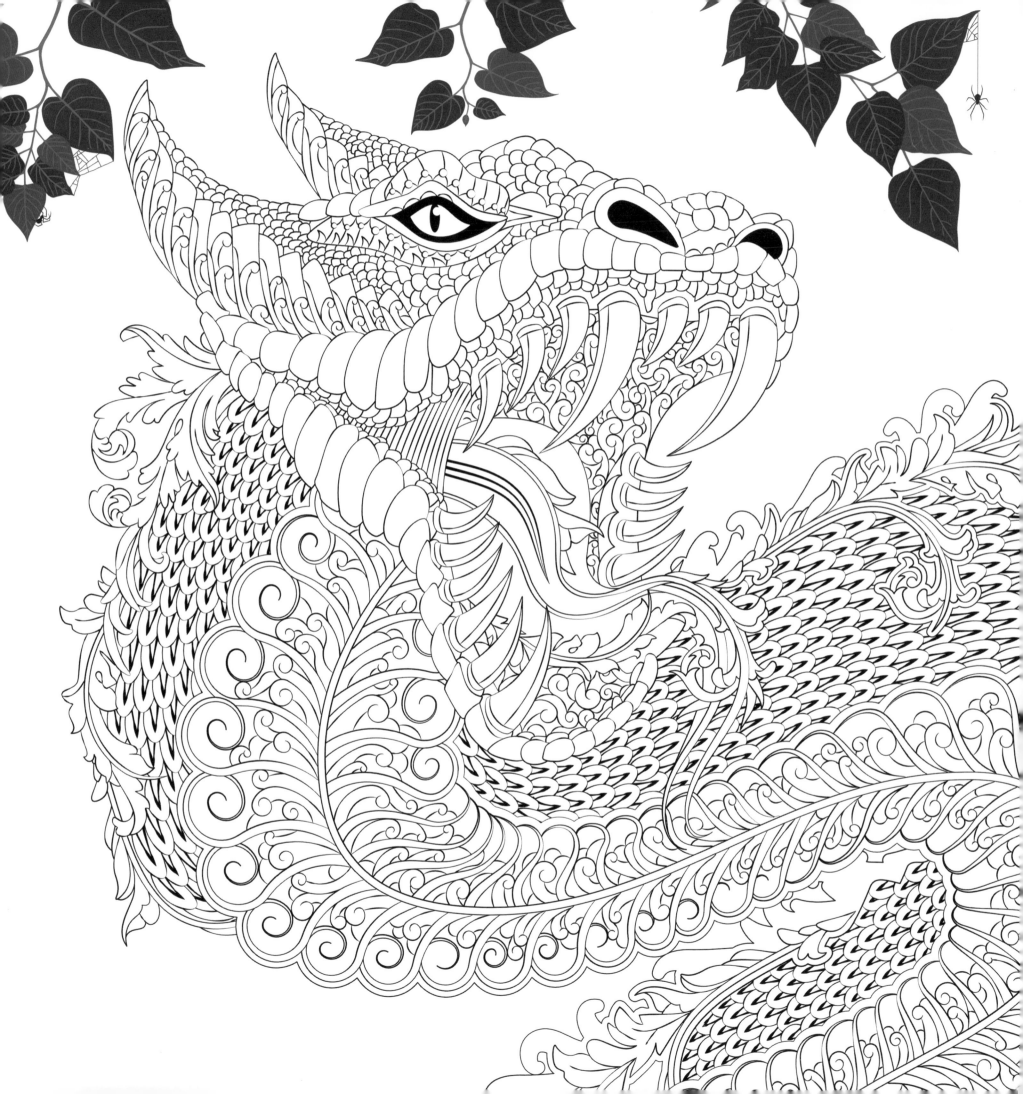

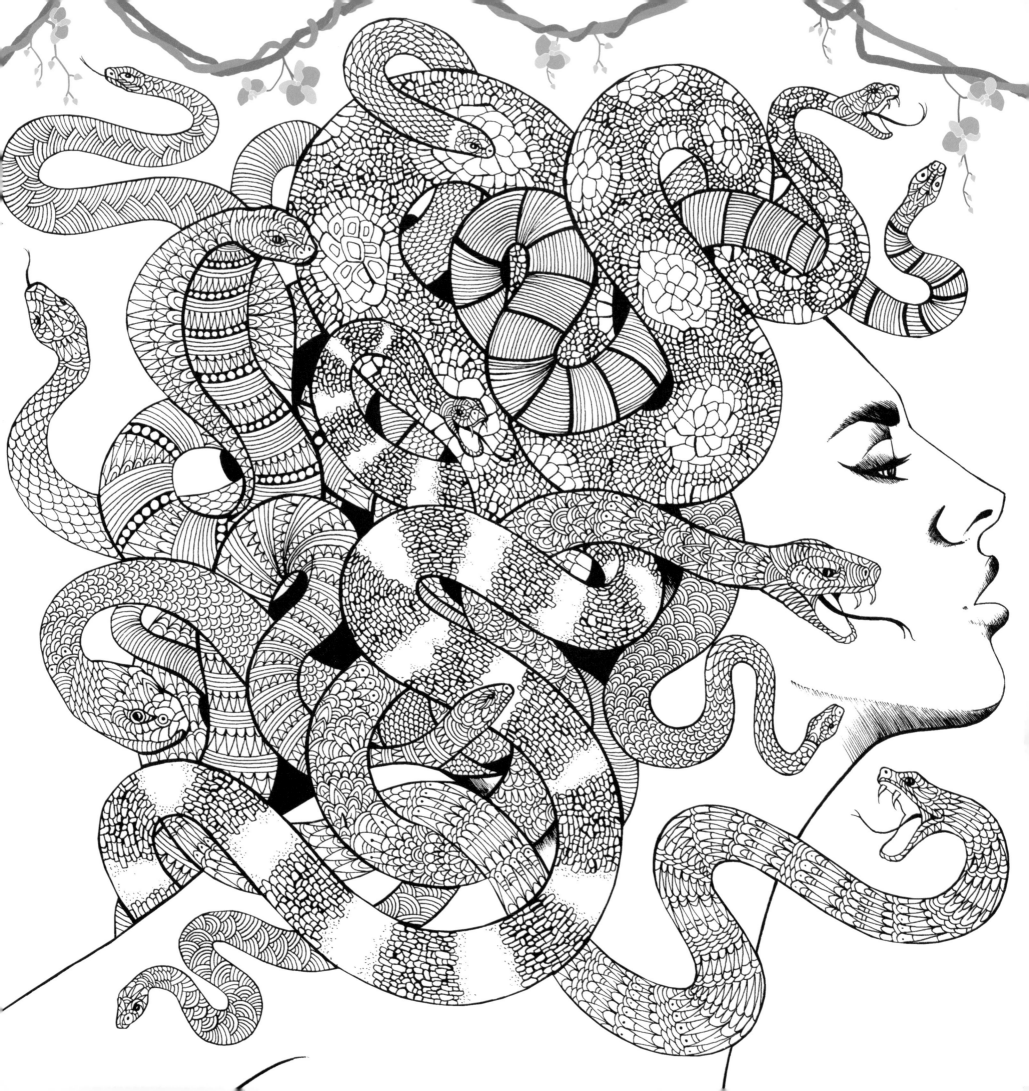

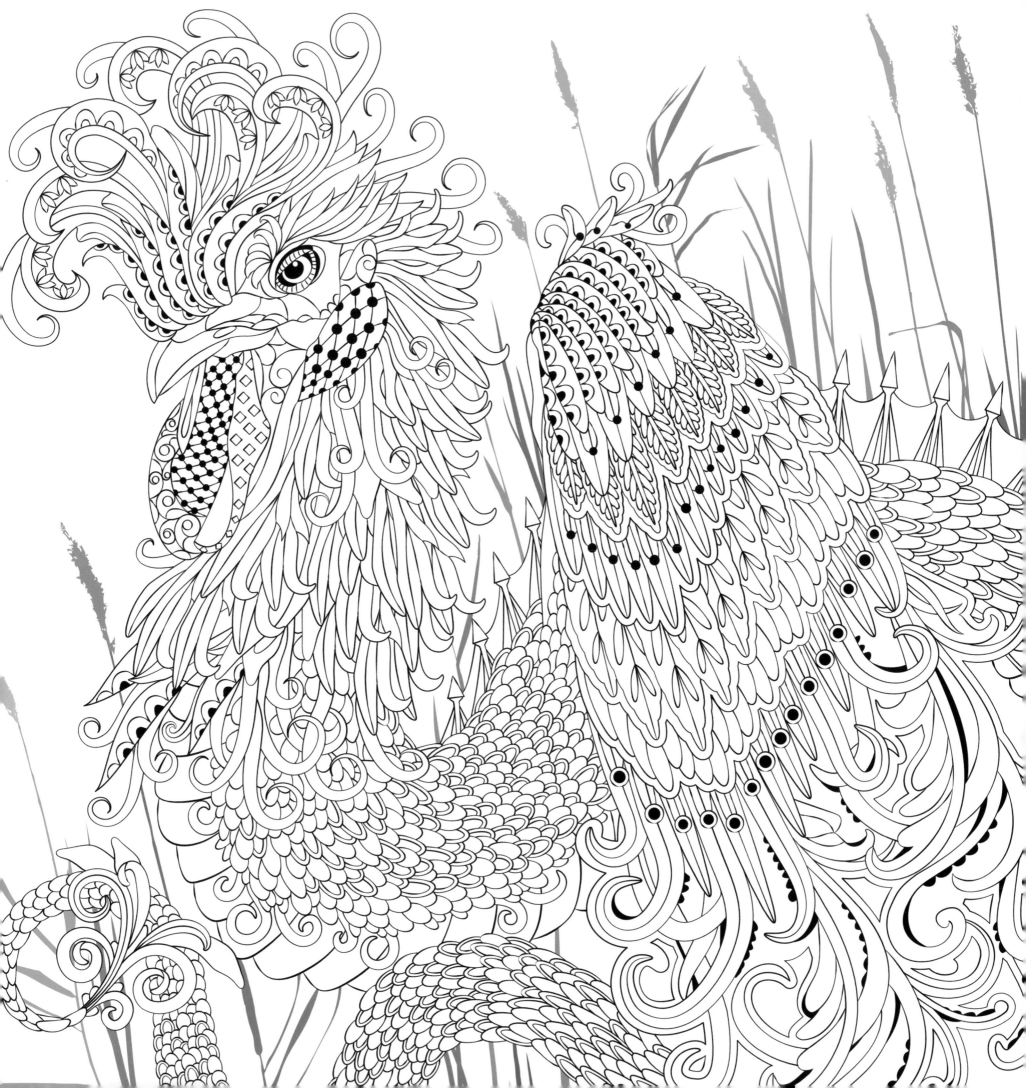

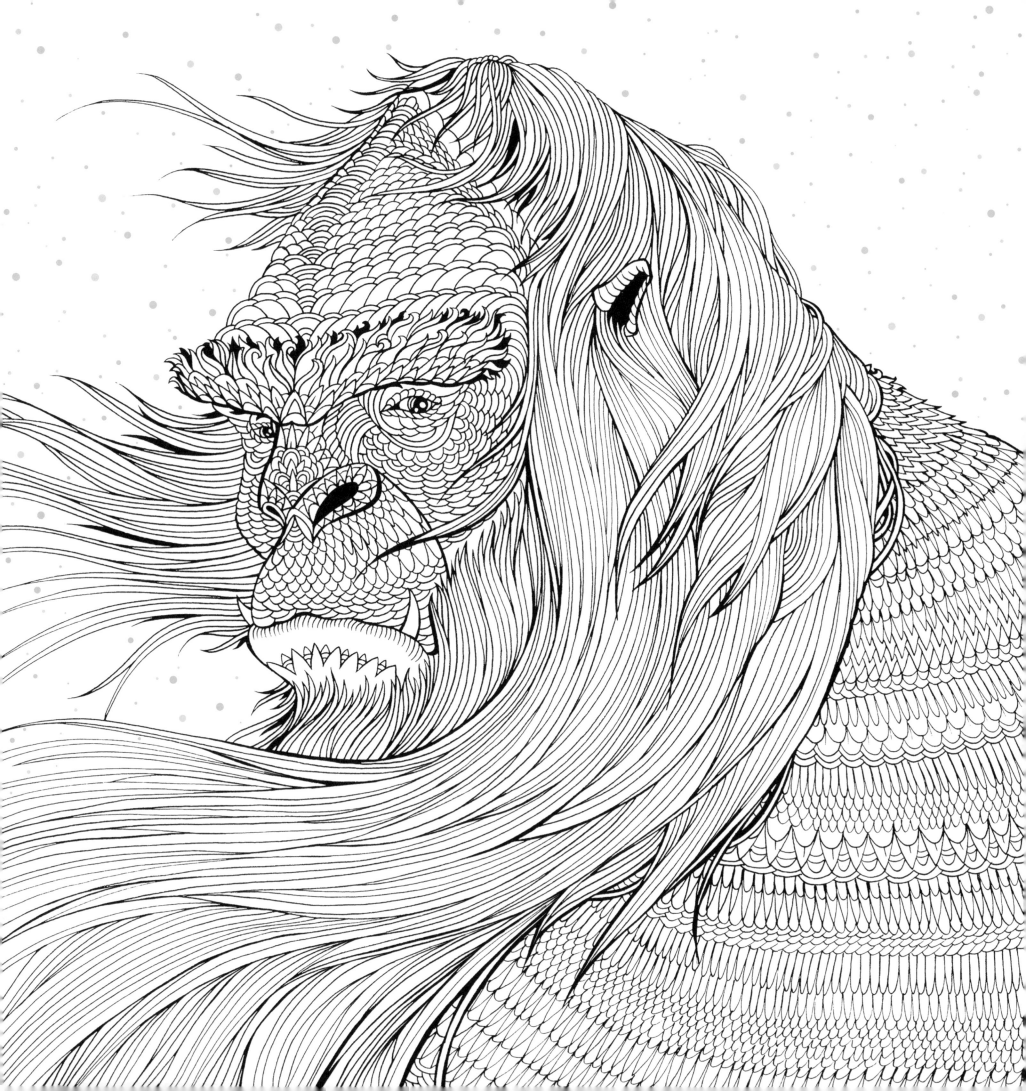

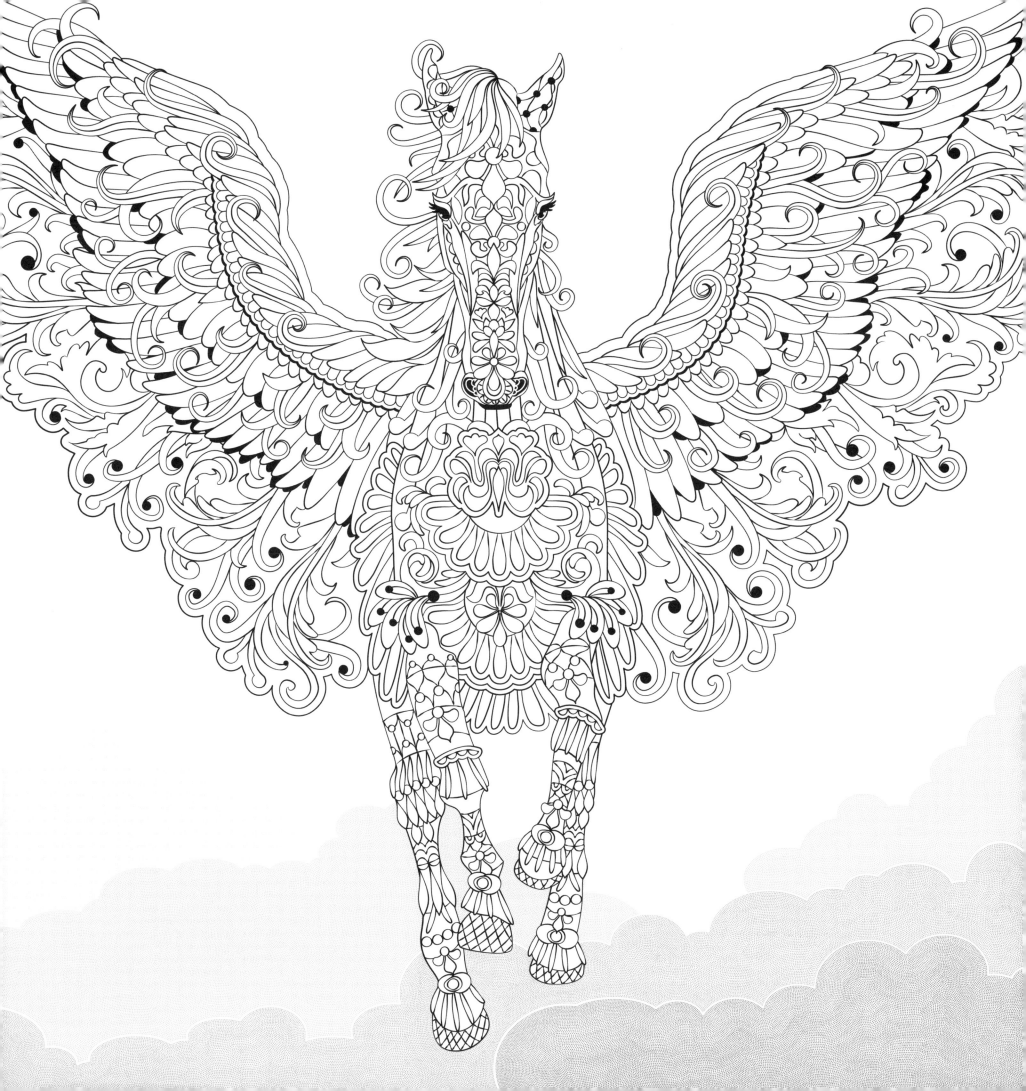

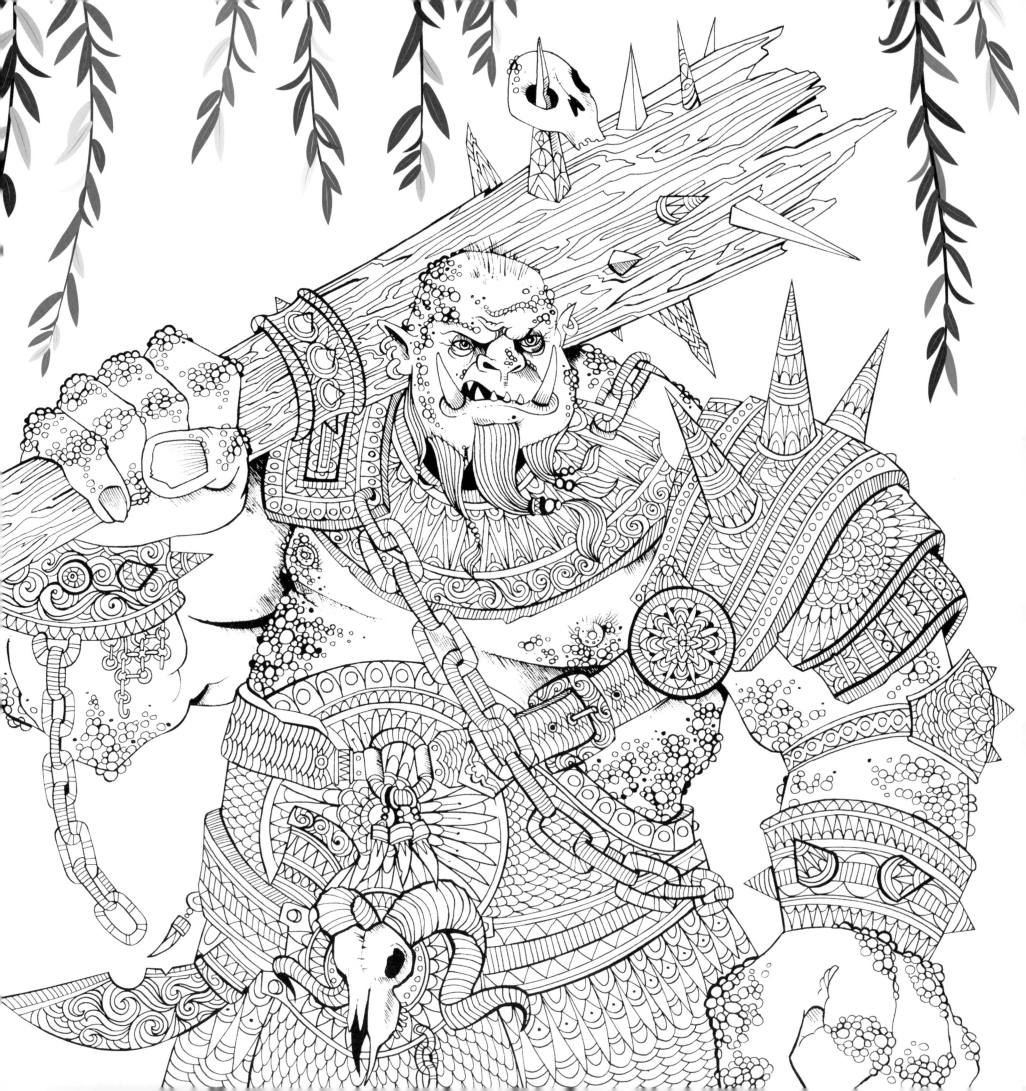

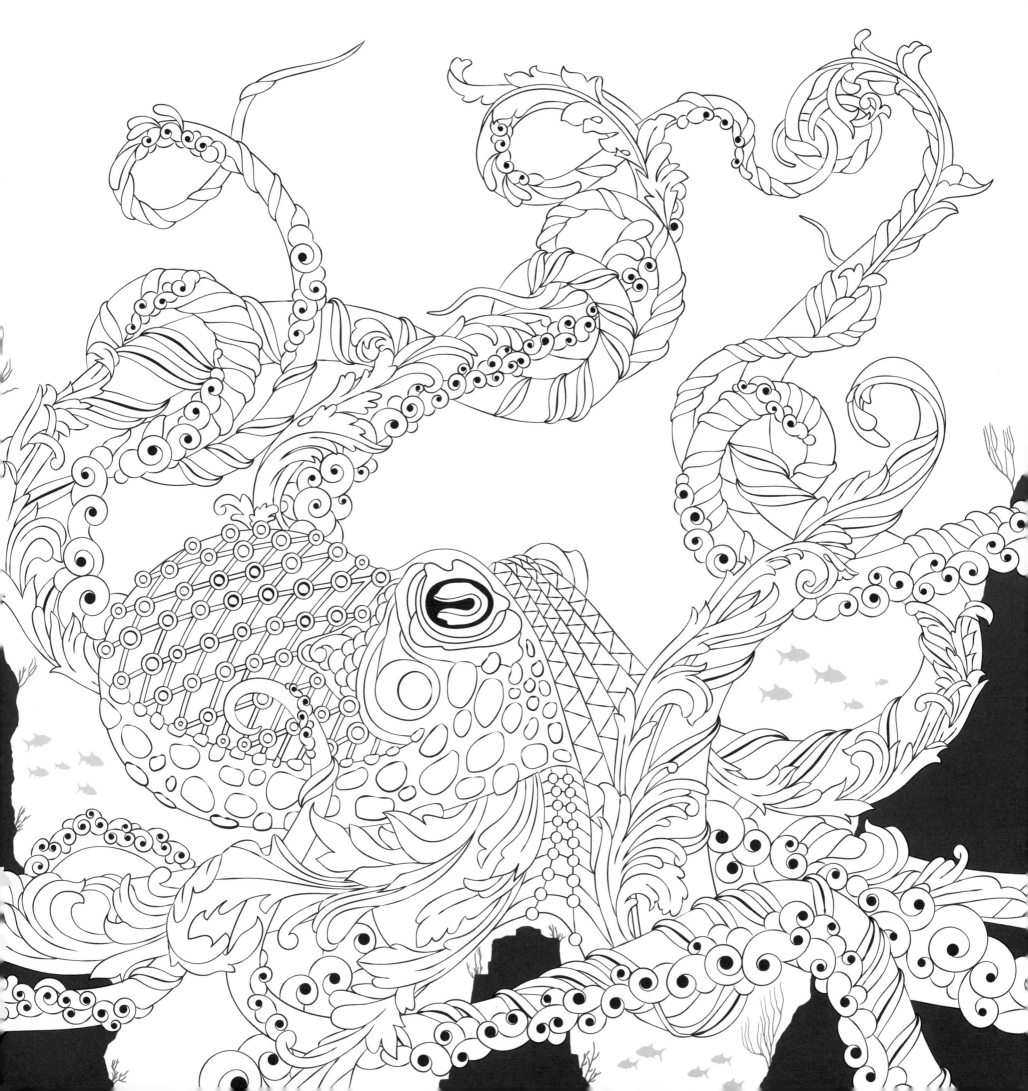

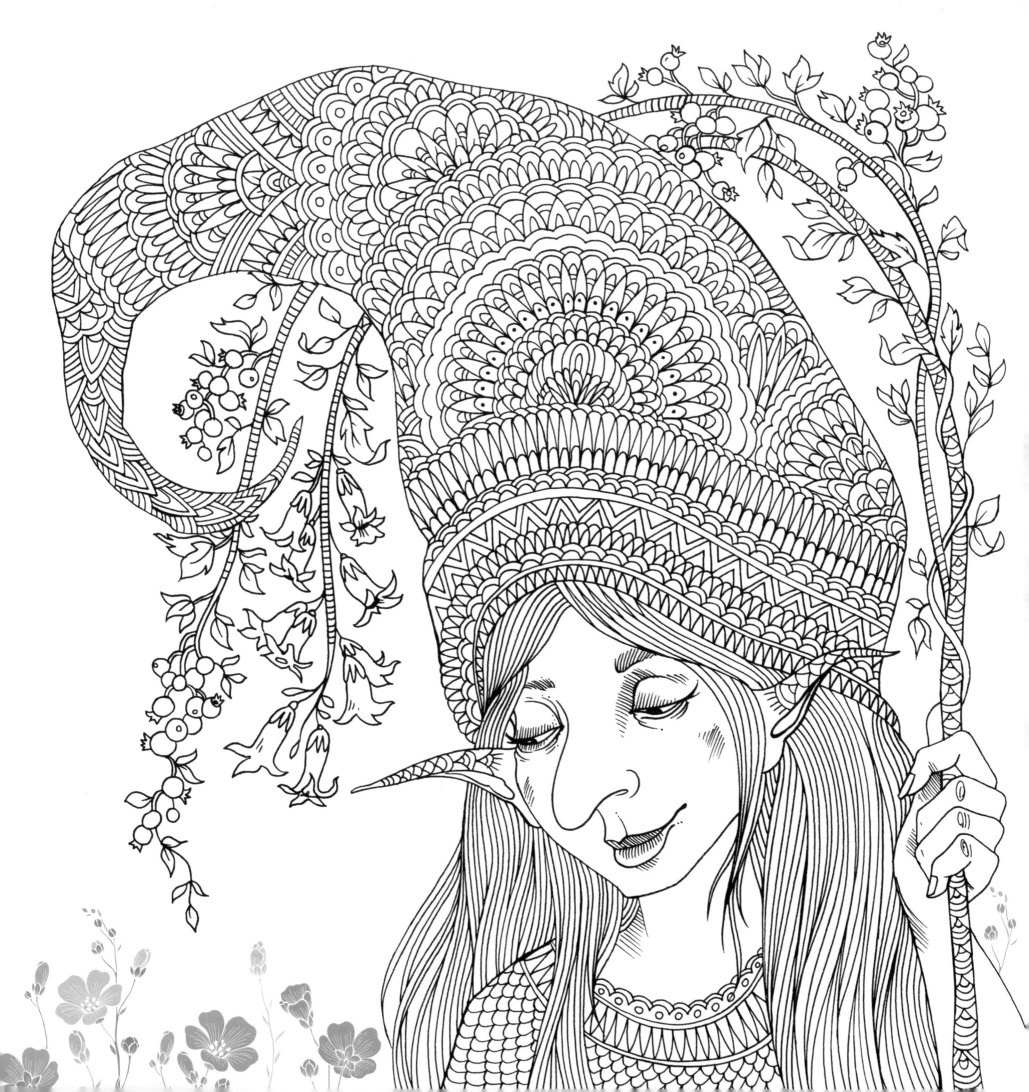

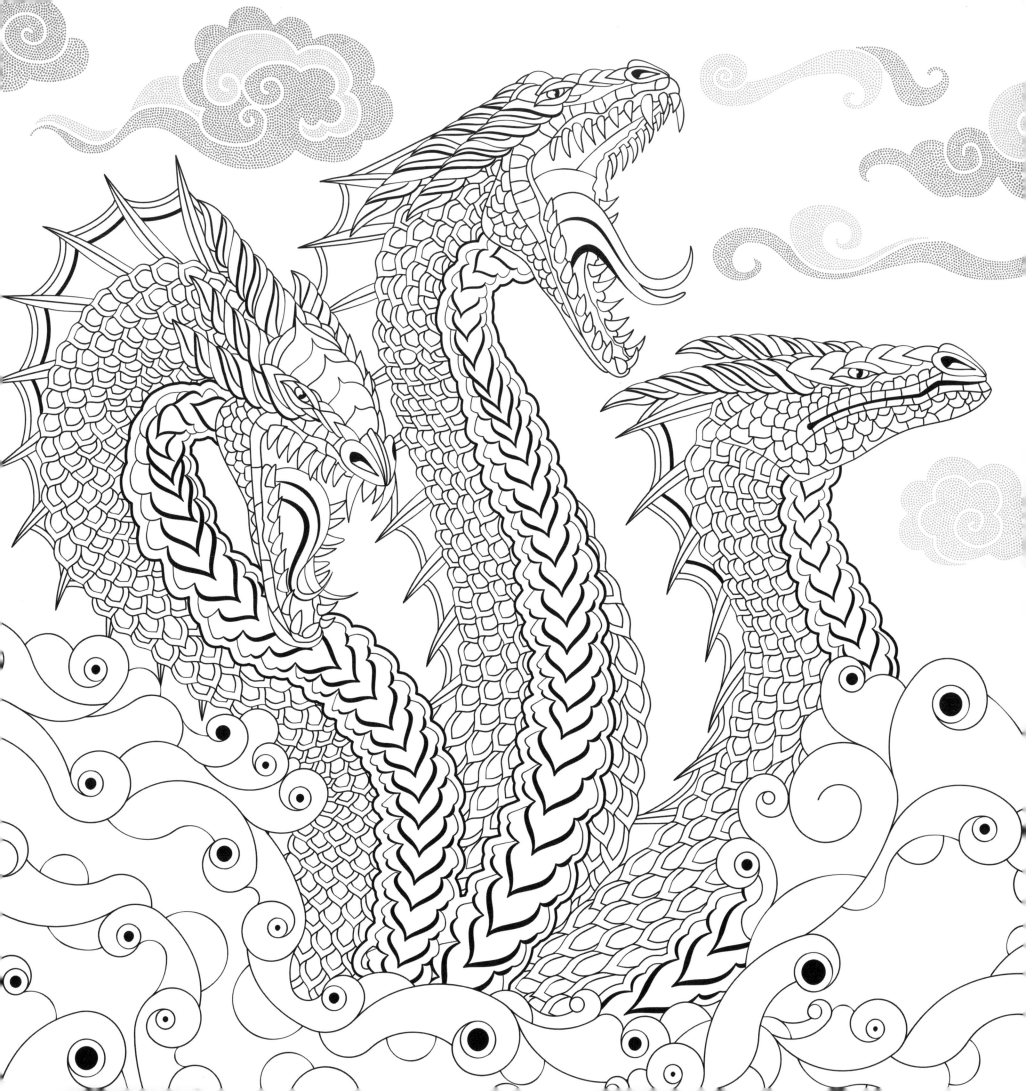

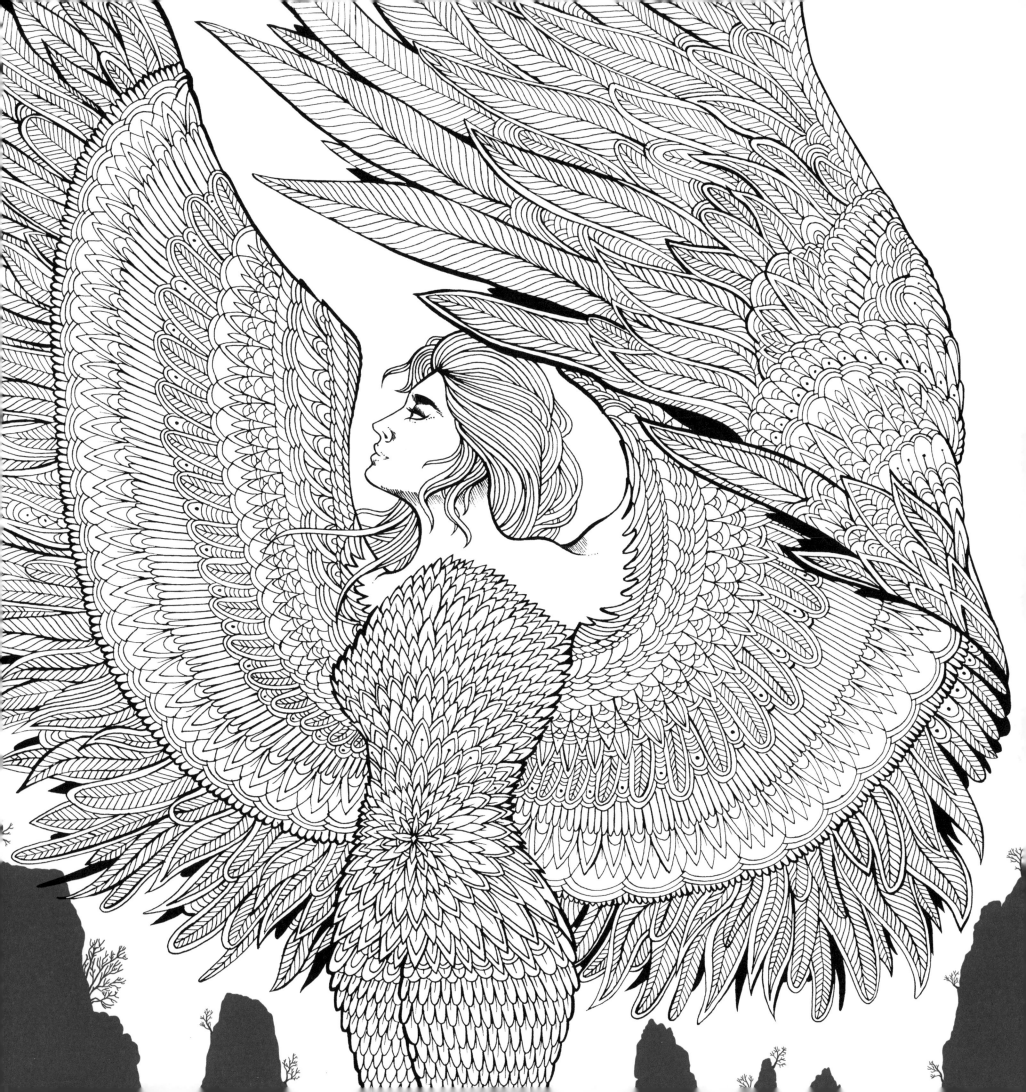

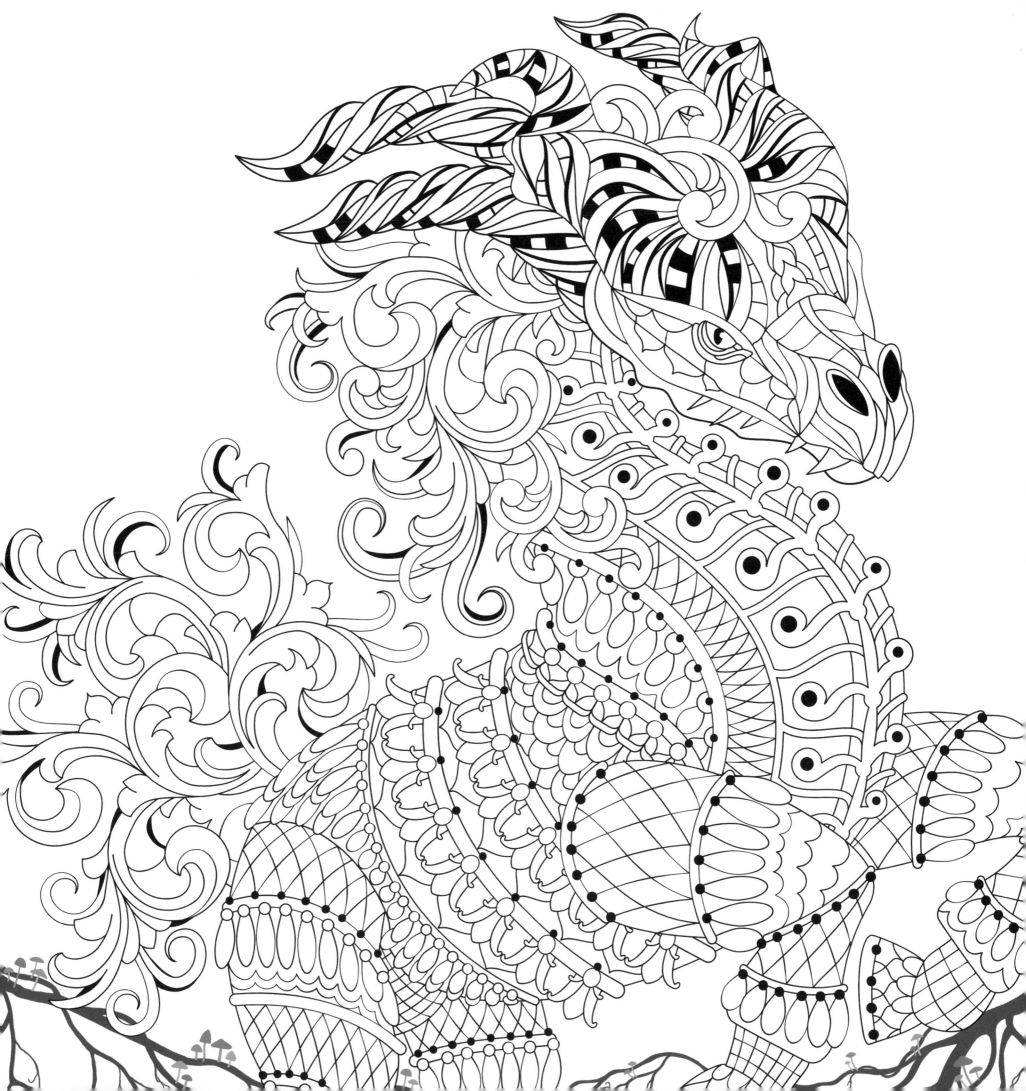

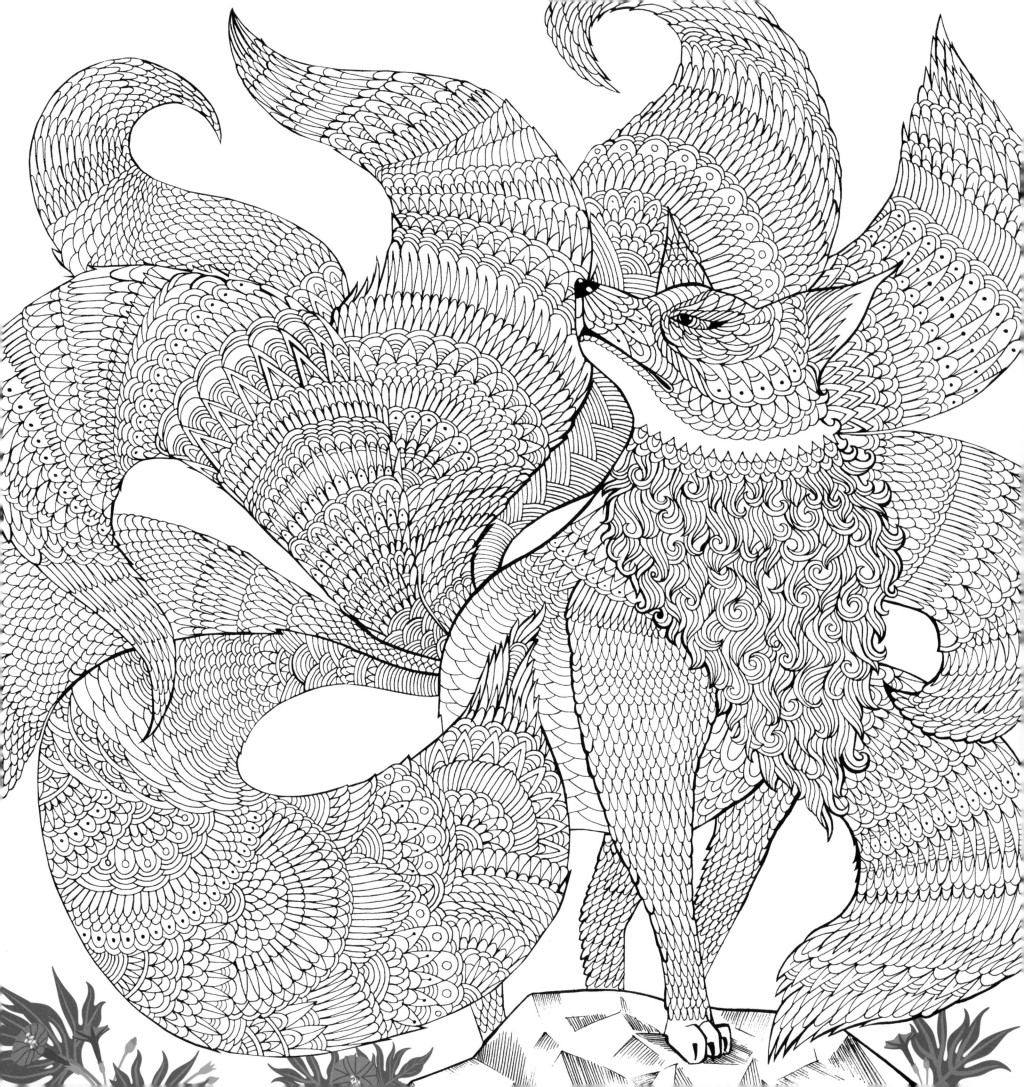

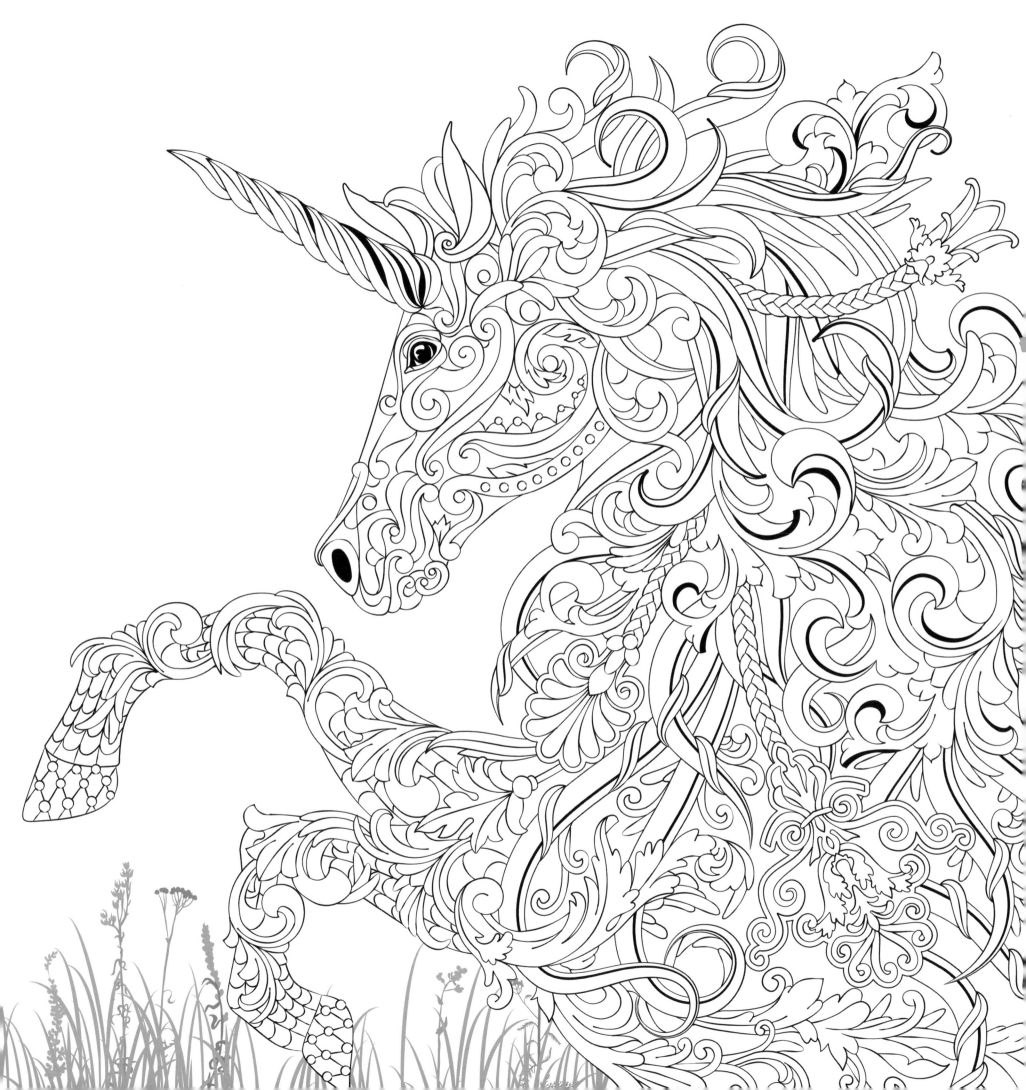

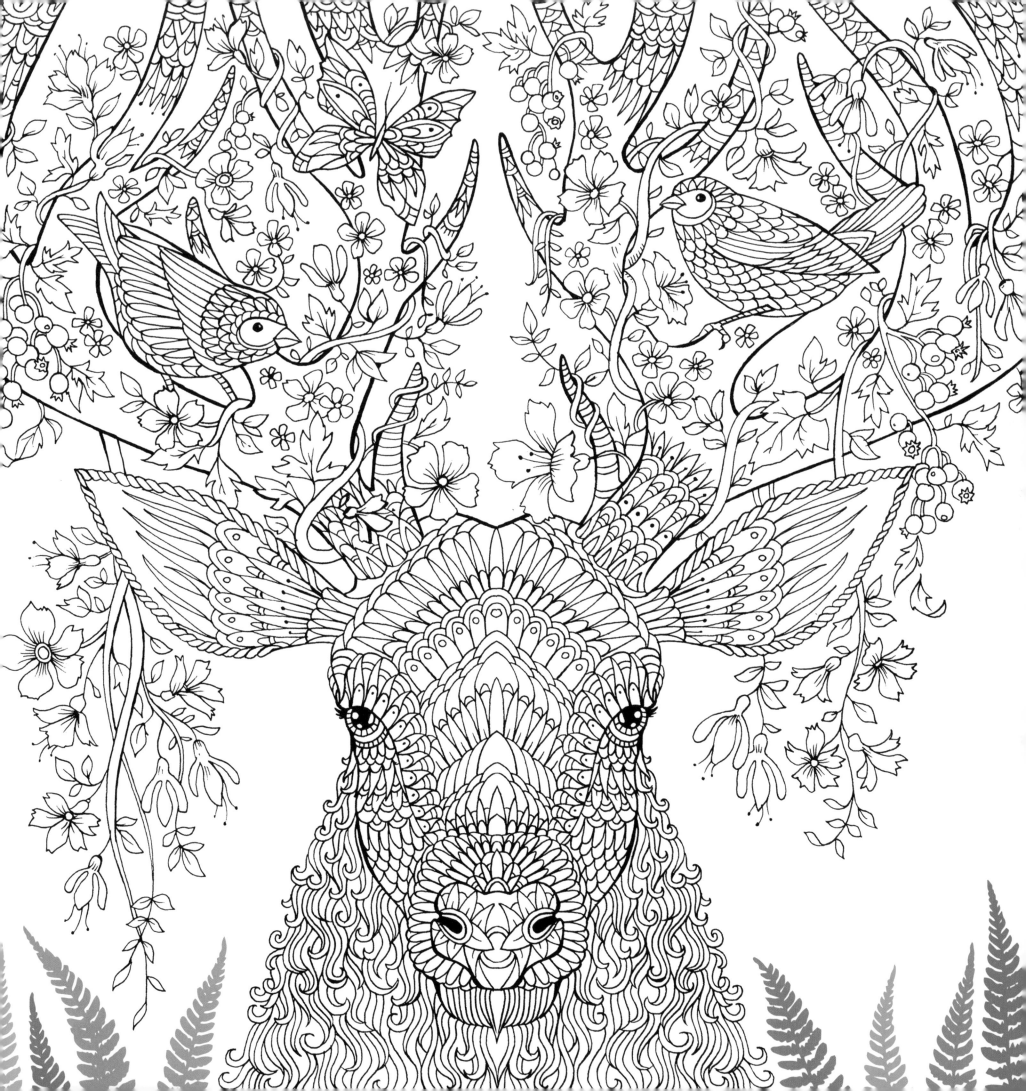

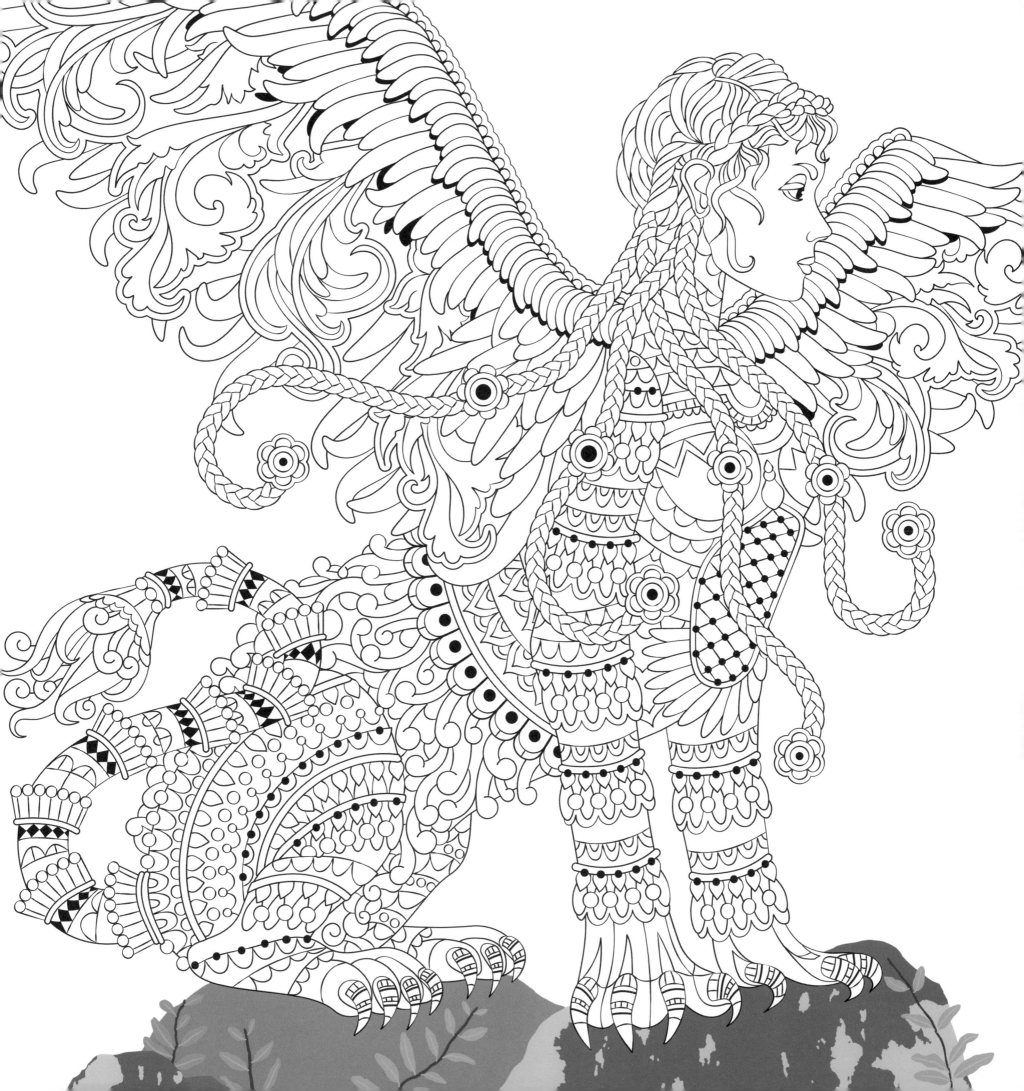

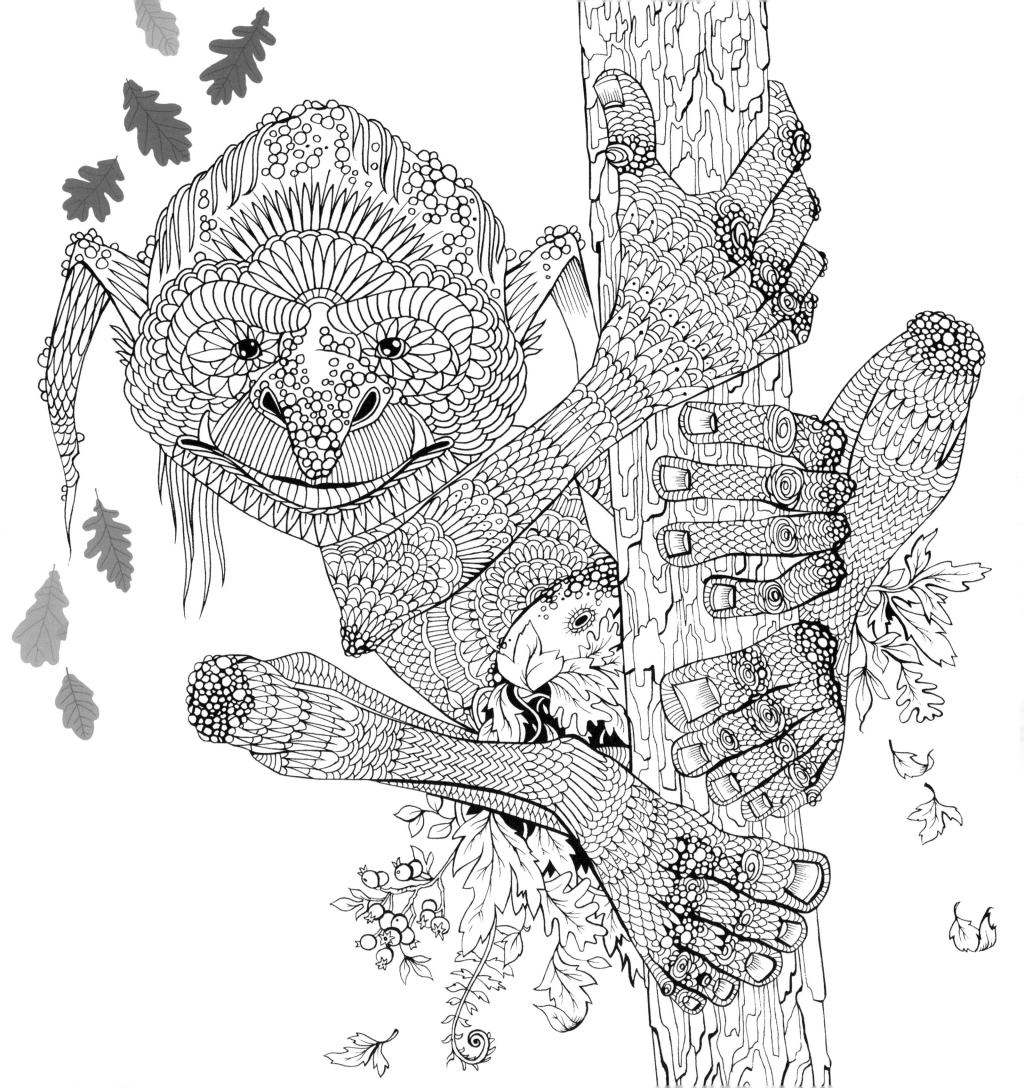

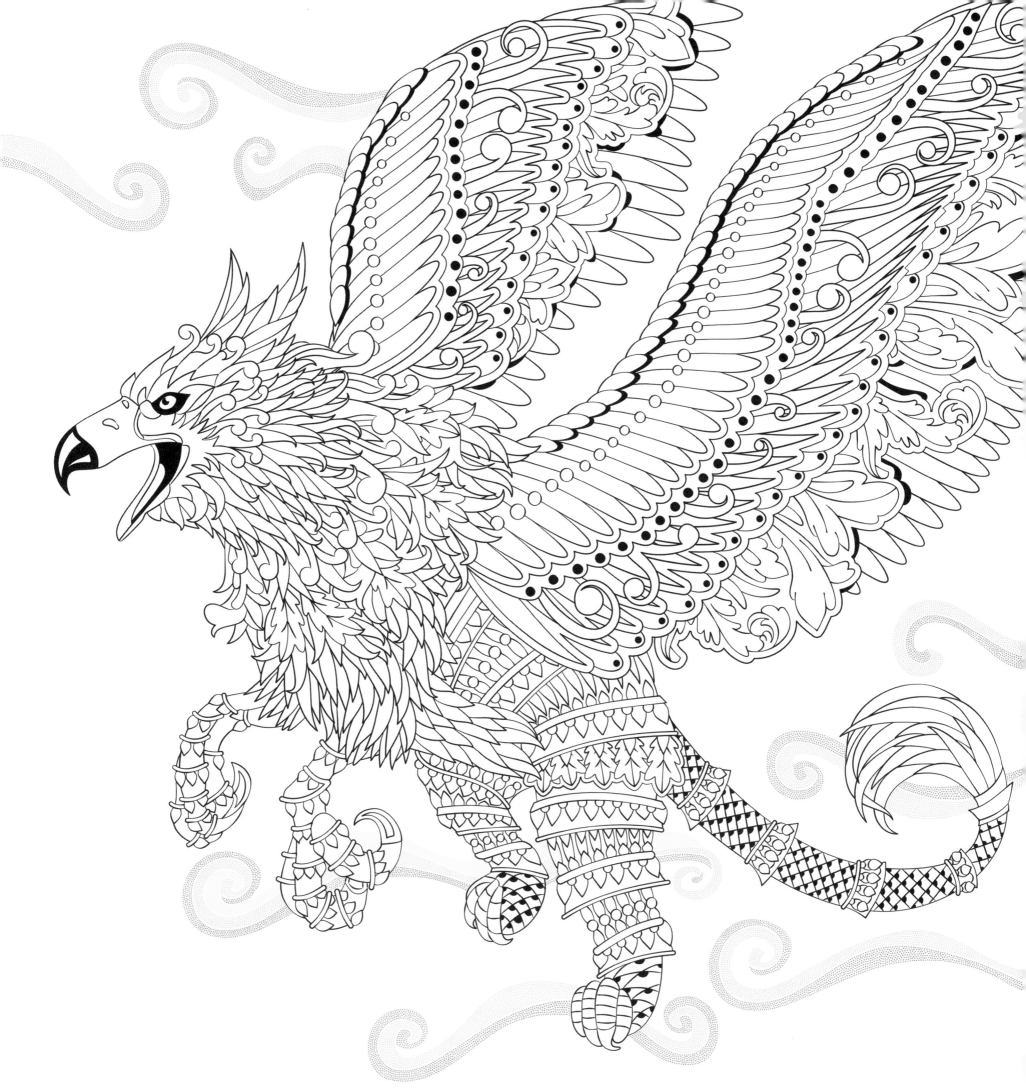

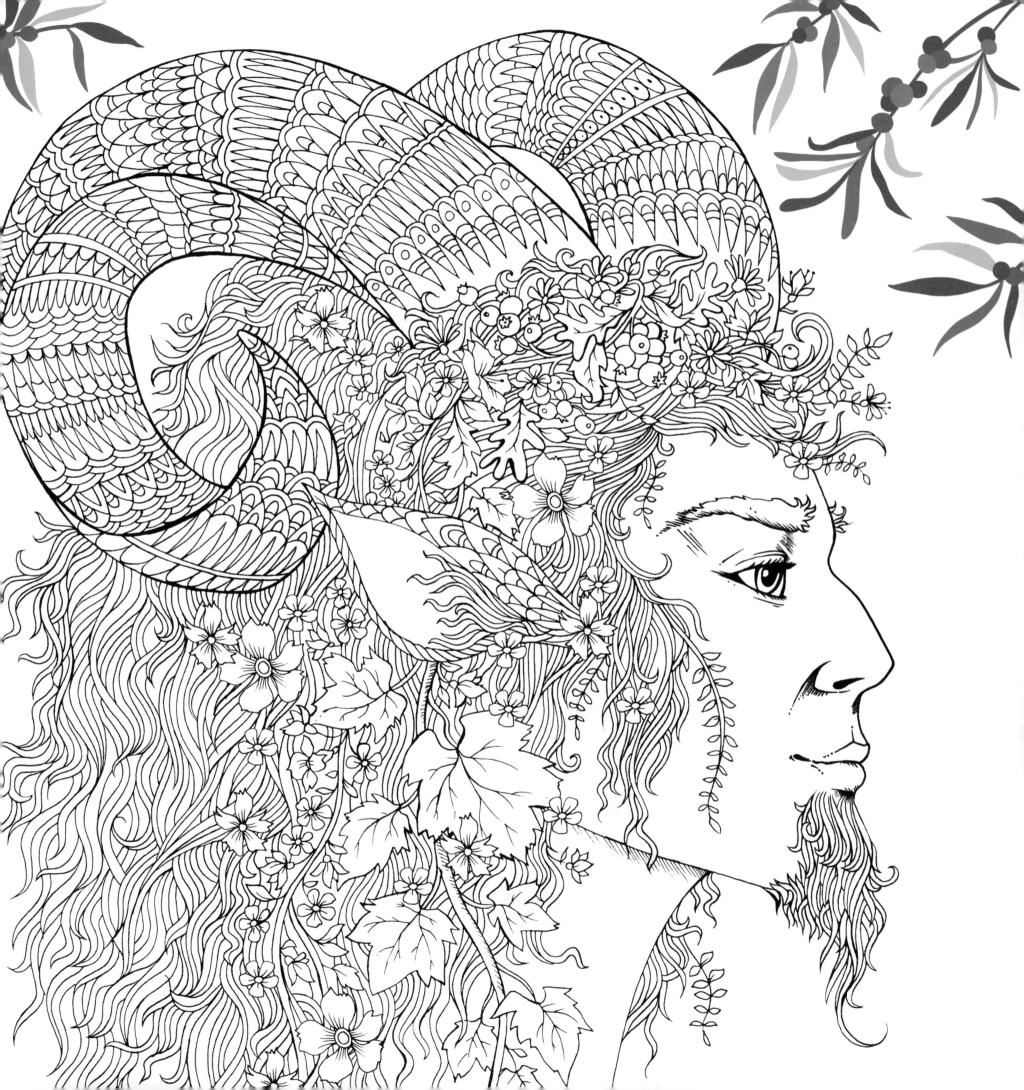

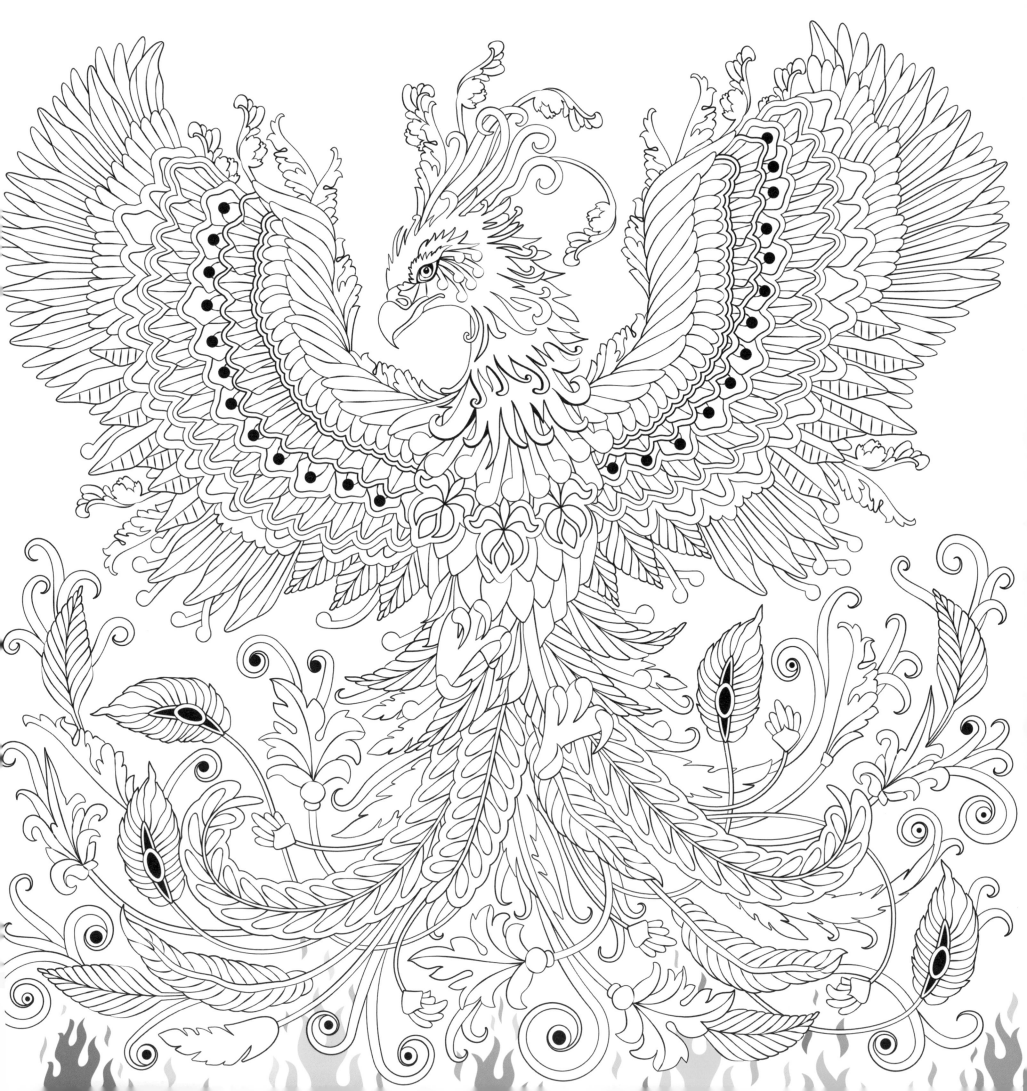

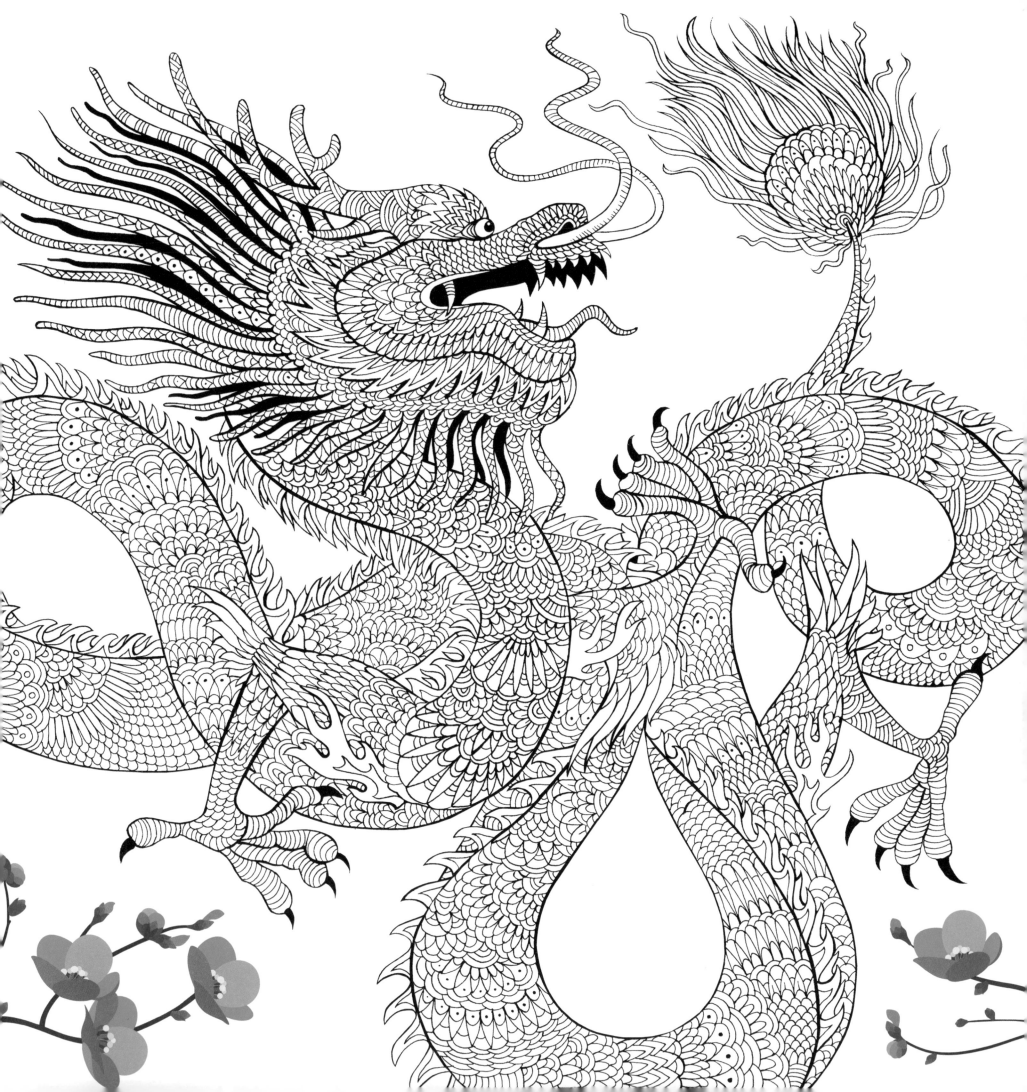

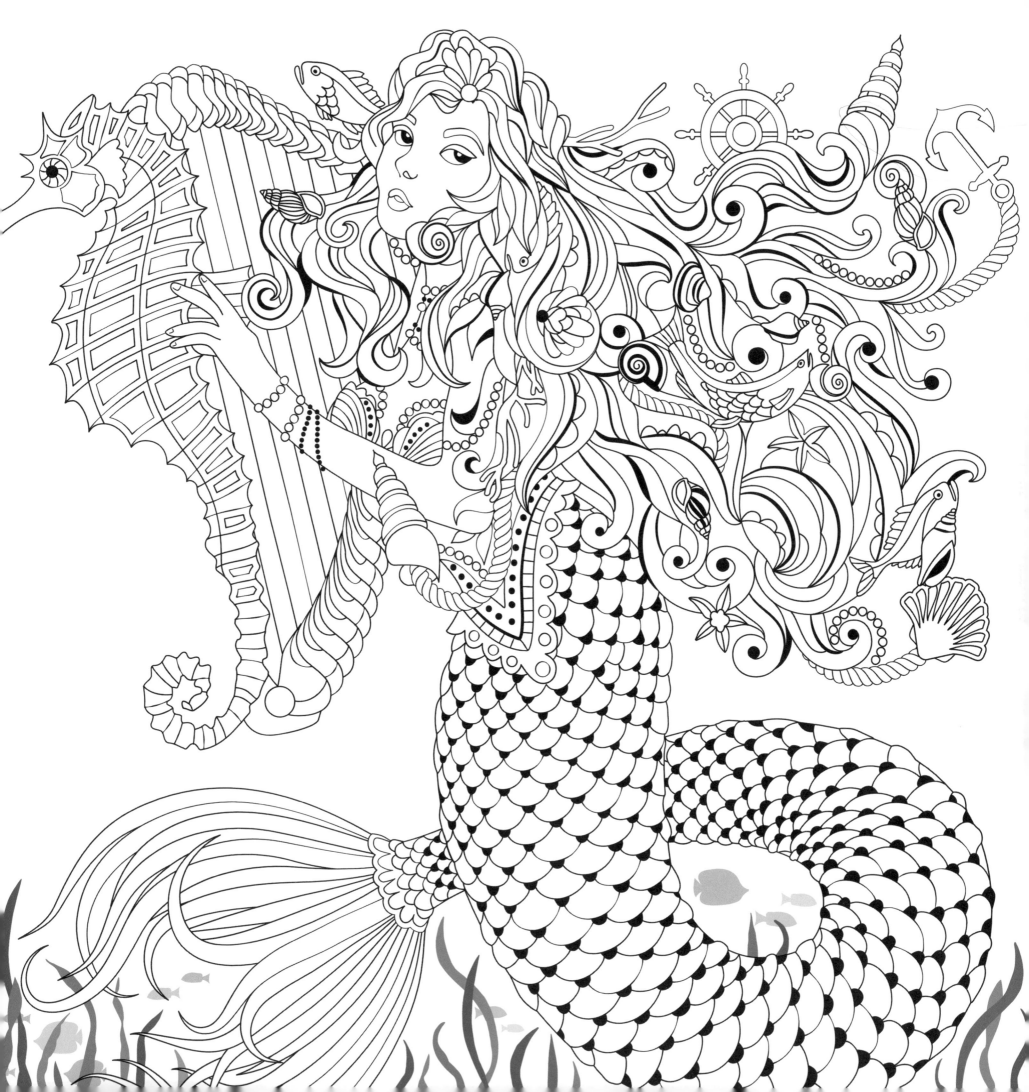

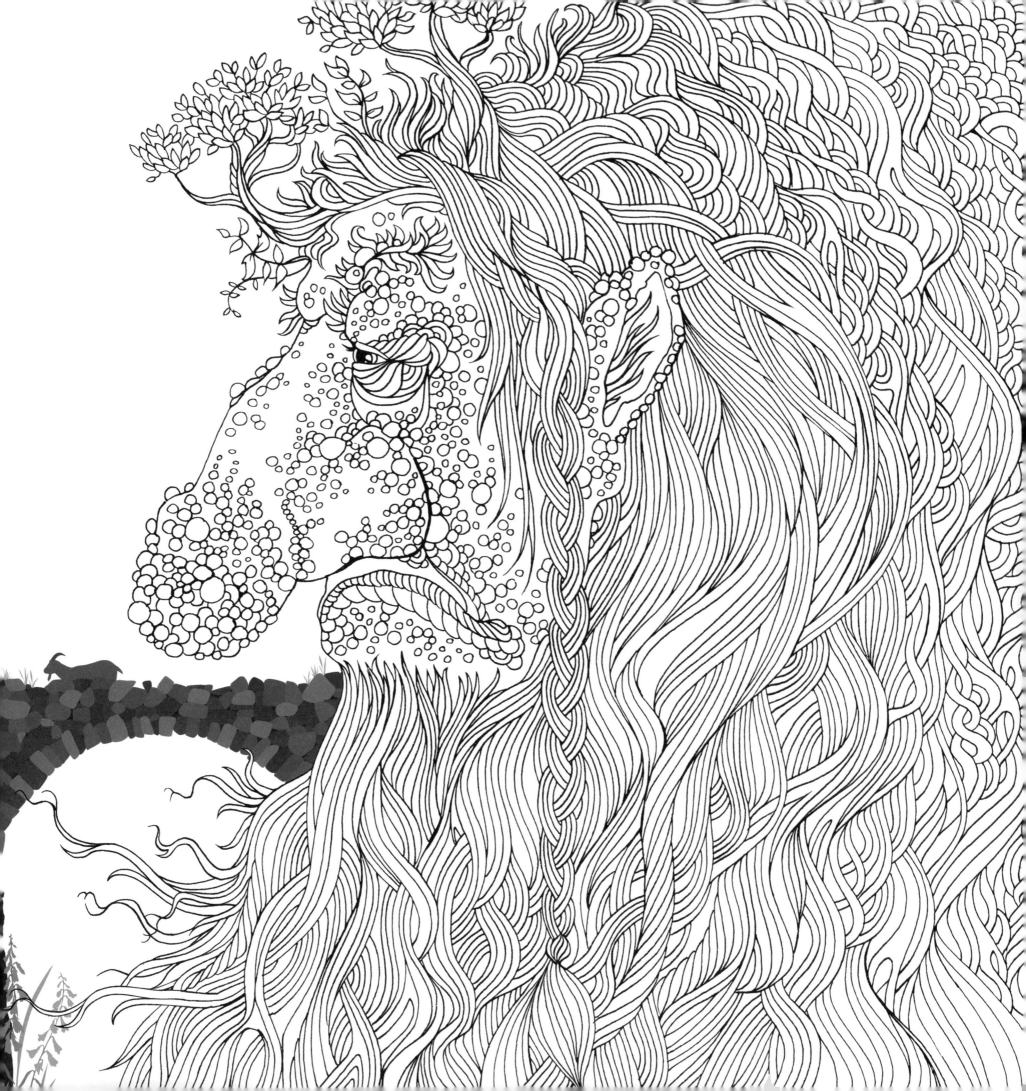

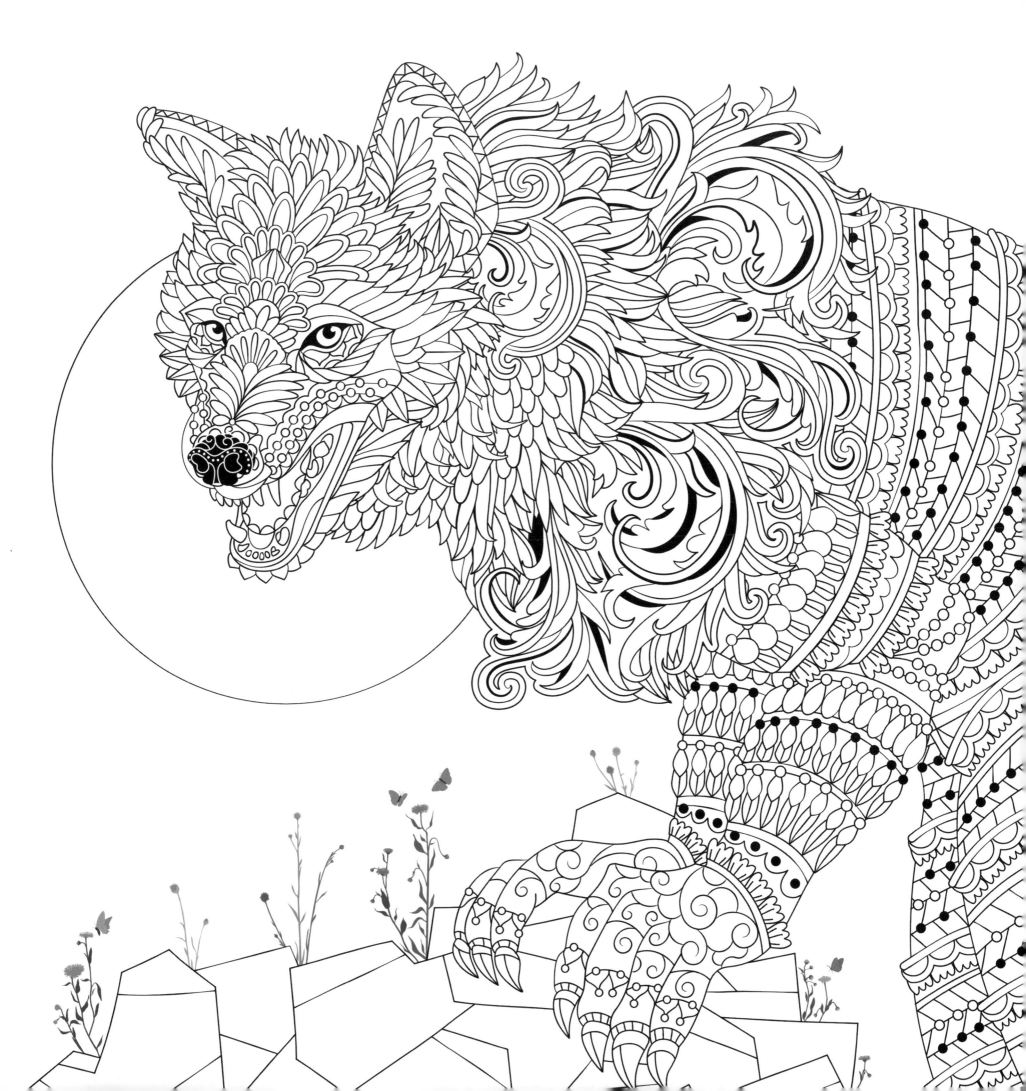

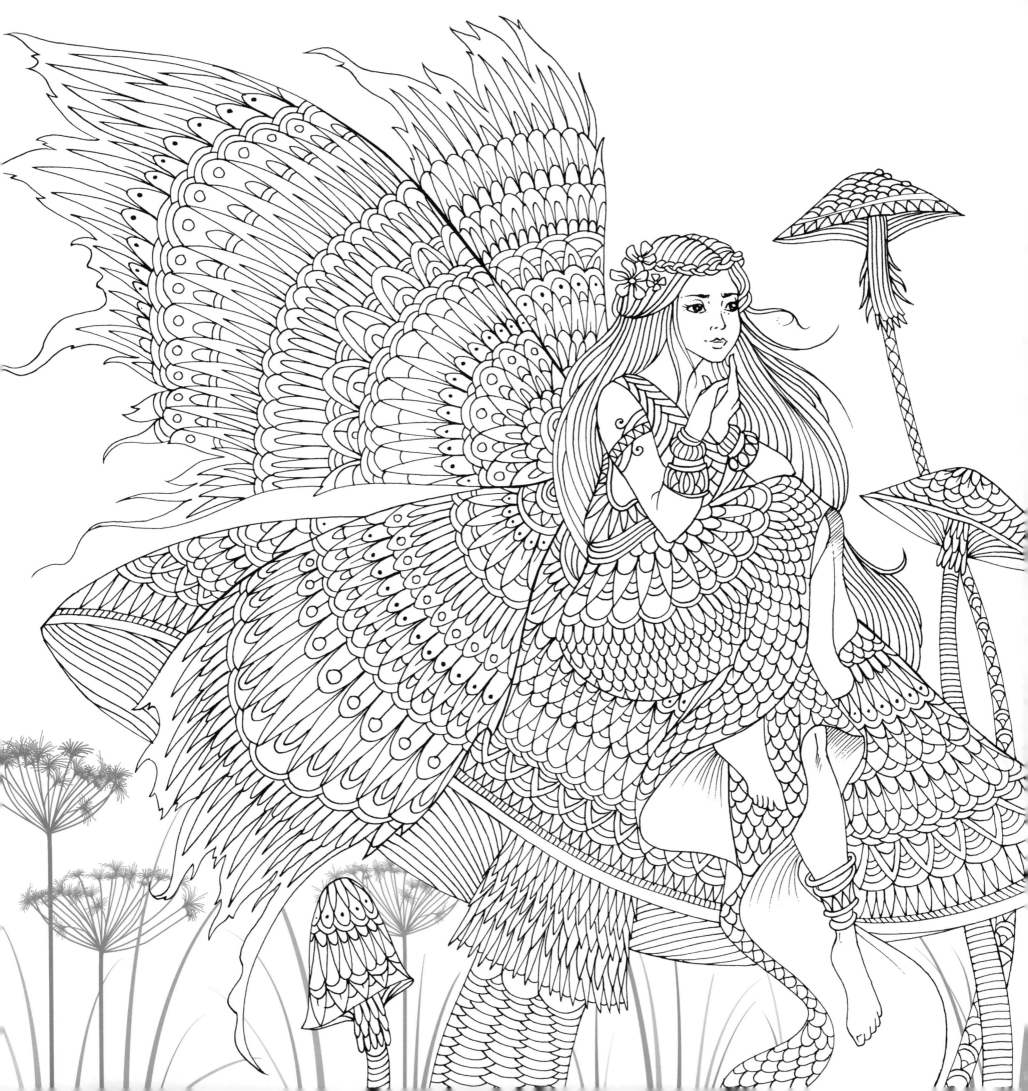

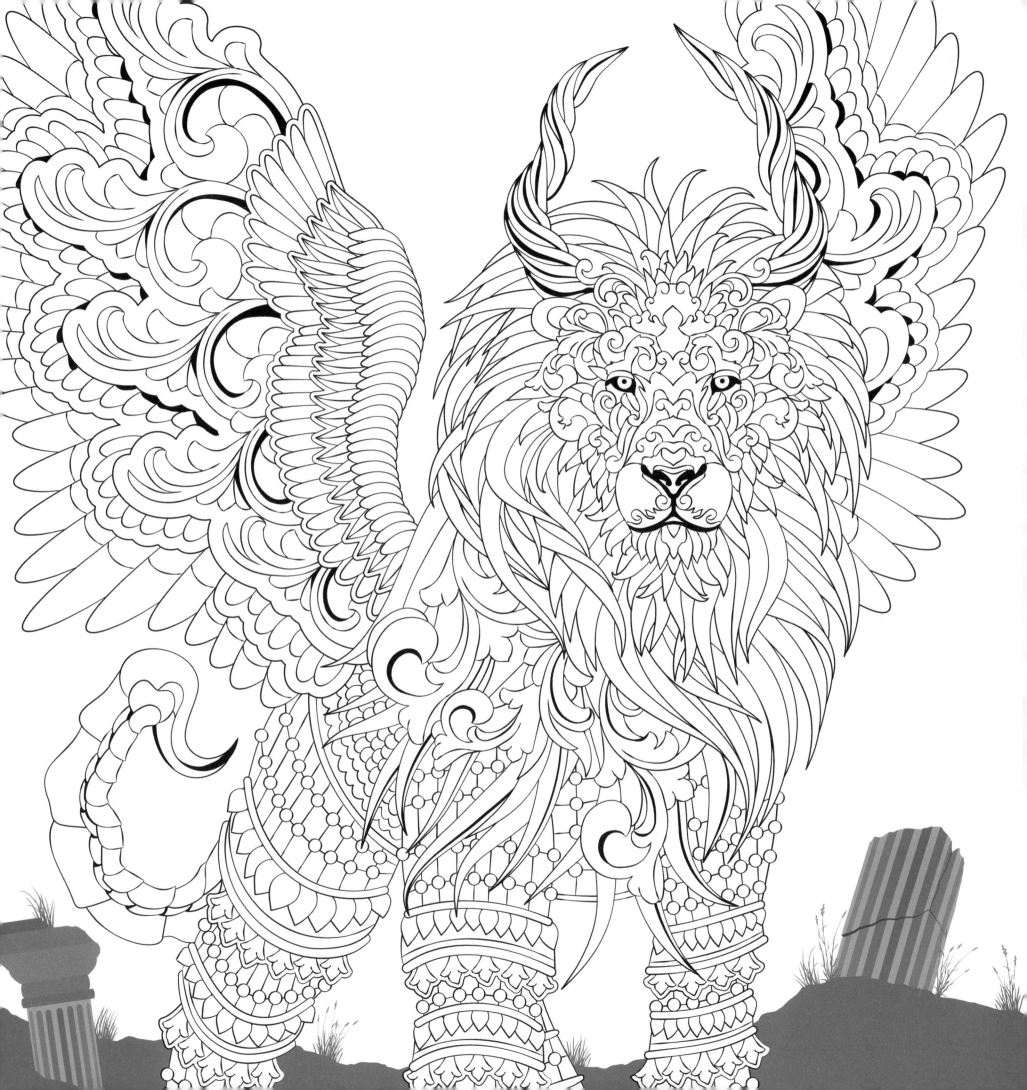

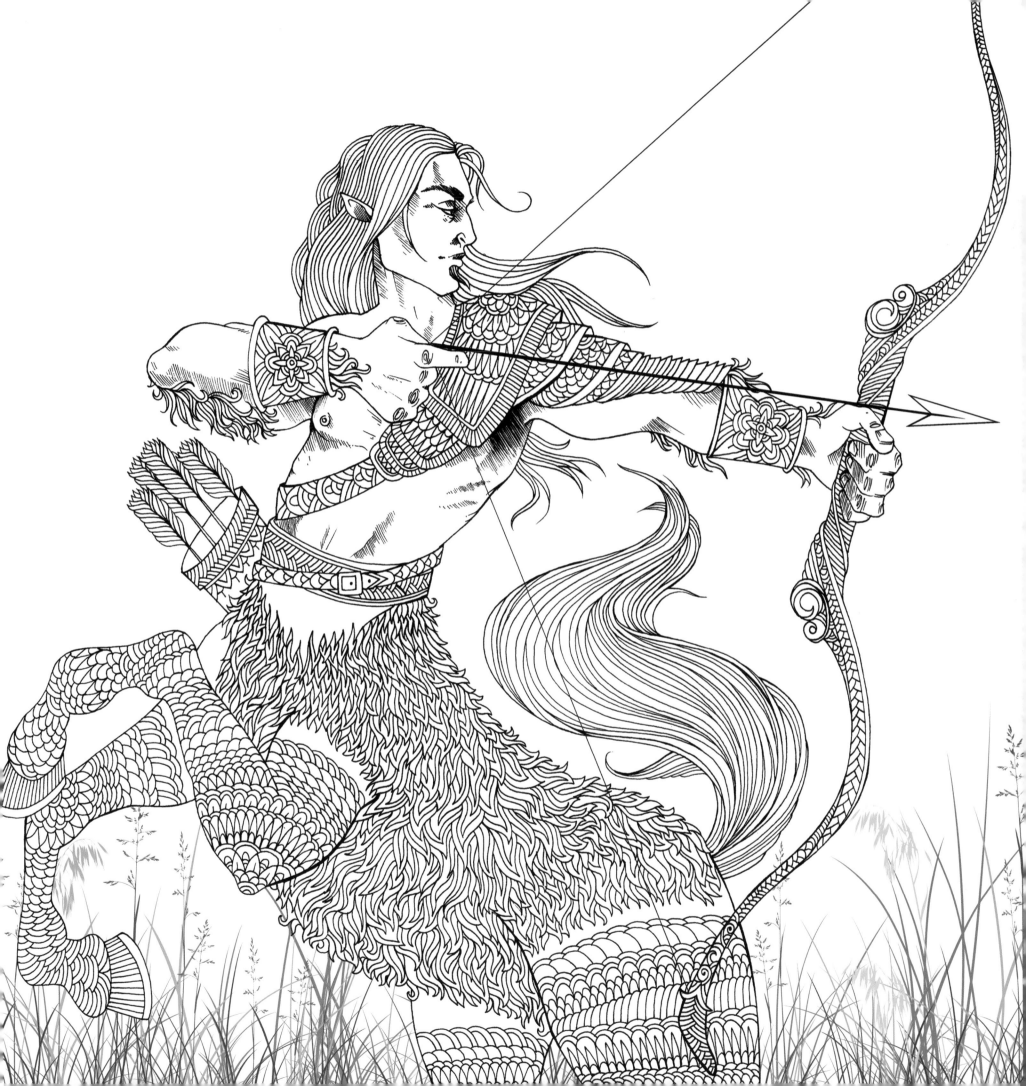

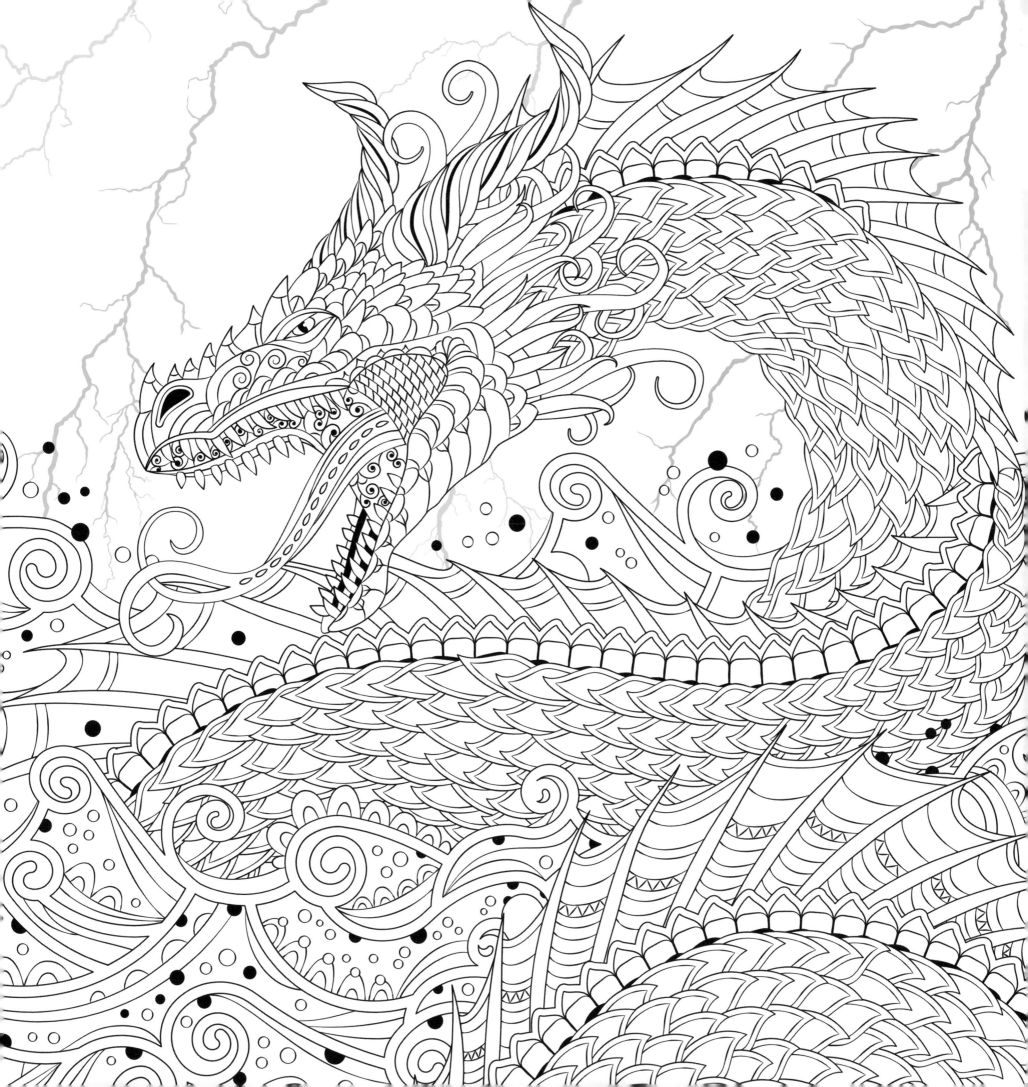

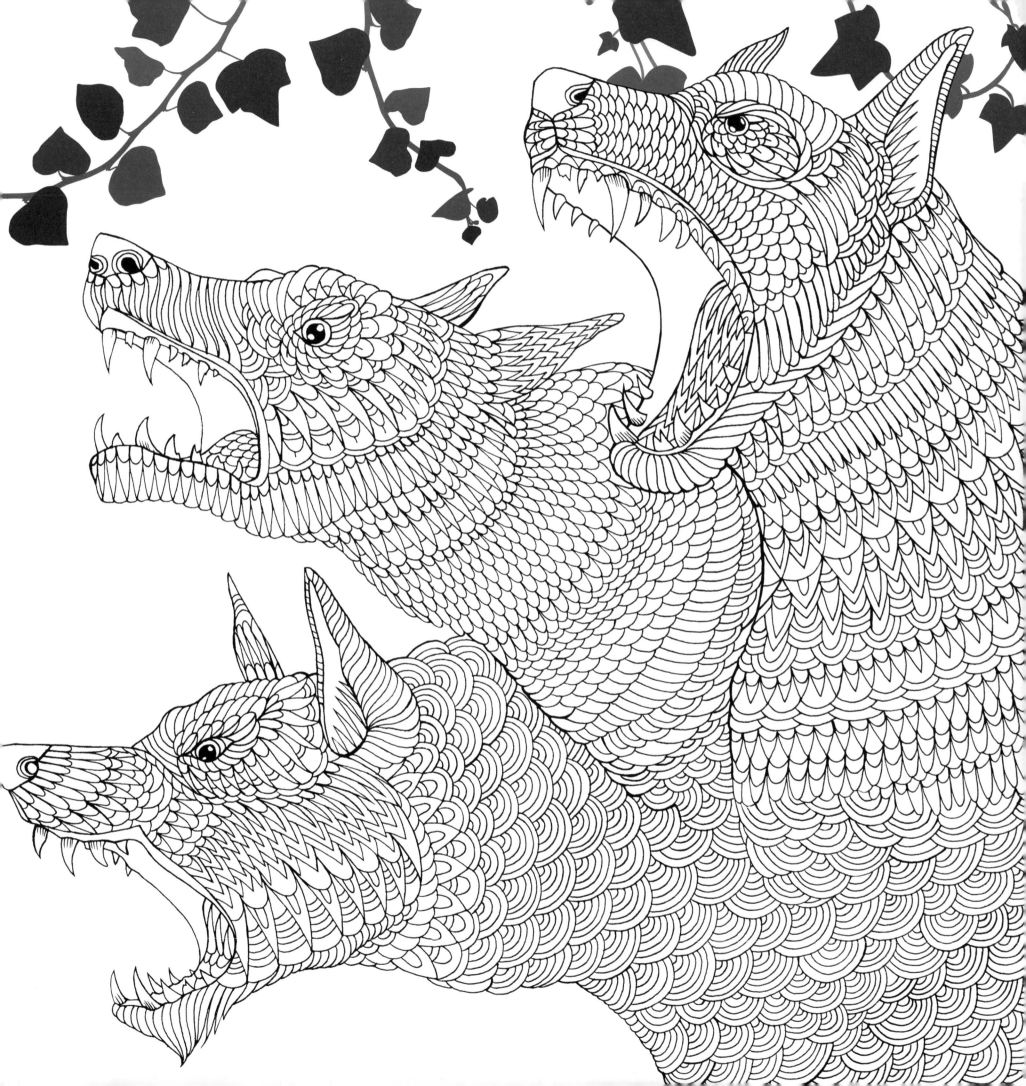